FREE FREE PALESTINE
،الحرية لفلسطين

by
Barbara Cook

A photo essay of solidarity with the palestinian people.

The Israeli-Palestinian conflict is ongoing and began in the mid 20th century. The struggle centers around ownership of land of which there is much written. The UN General Assembley voted to recognise Palestine as a state.

"Enough of aggression, settlements and occupation," said Mahmoud Abbas, President of the Palestinian Authority.

This photo documentary was taken over a three year period in Britain when the news featured heavily the bombardment that the Palestinian people were enduring. People took to the streets and marches took place nationally.

There are several UK based organisations involved in action to highlight the plight of Palestine and it's people, these photos show ordinary people standing up with a message of "Free Free Palestine".

When the people stop marching, when Palestine is not in the news, when domestic news is overwhelming that is when international solidarity is vital.

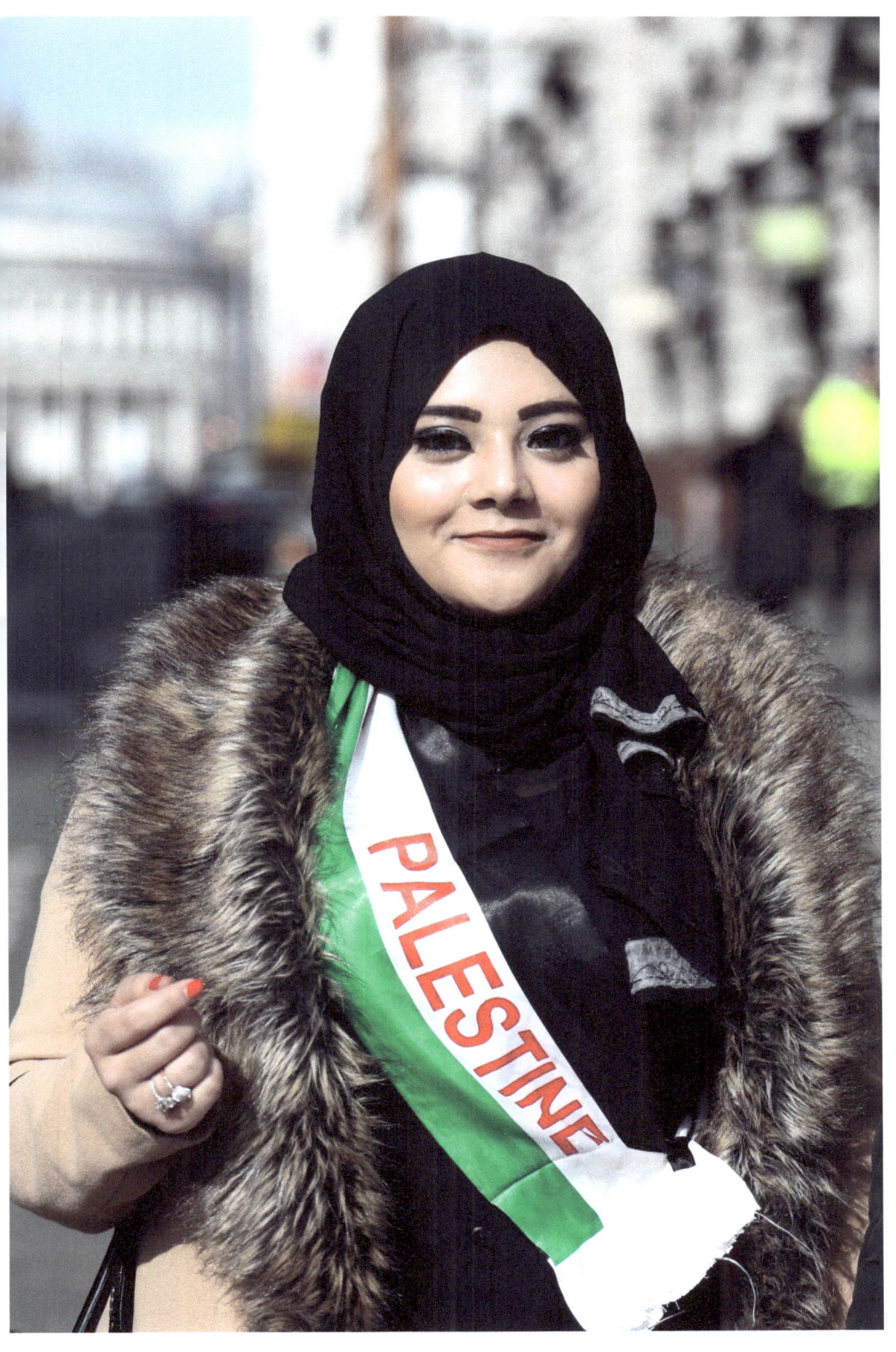

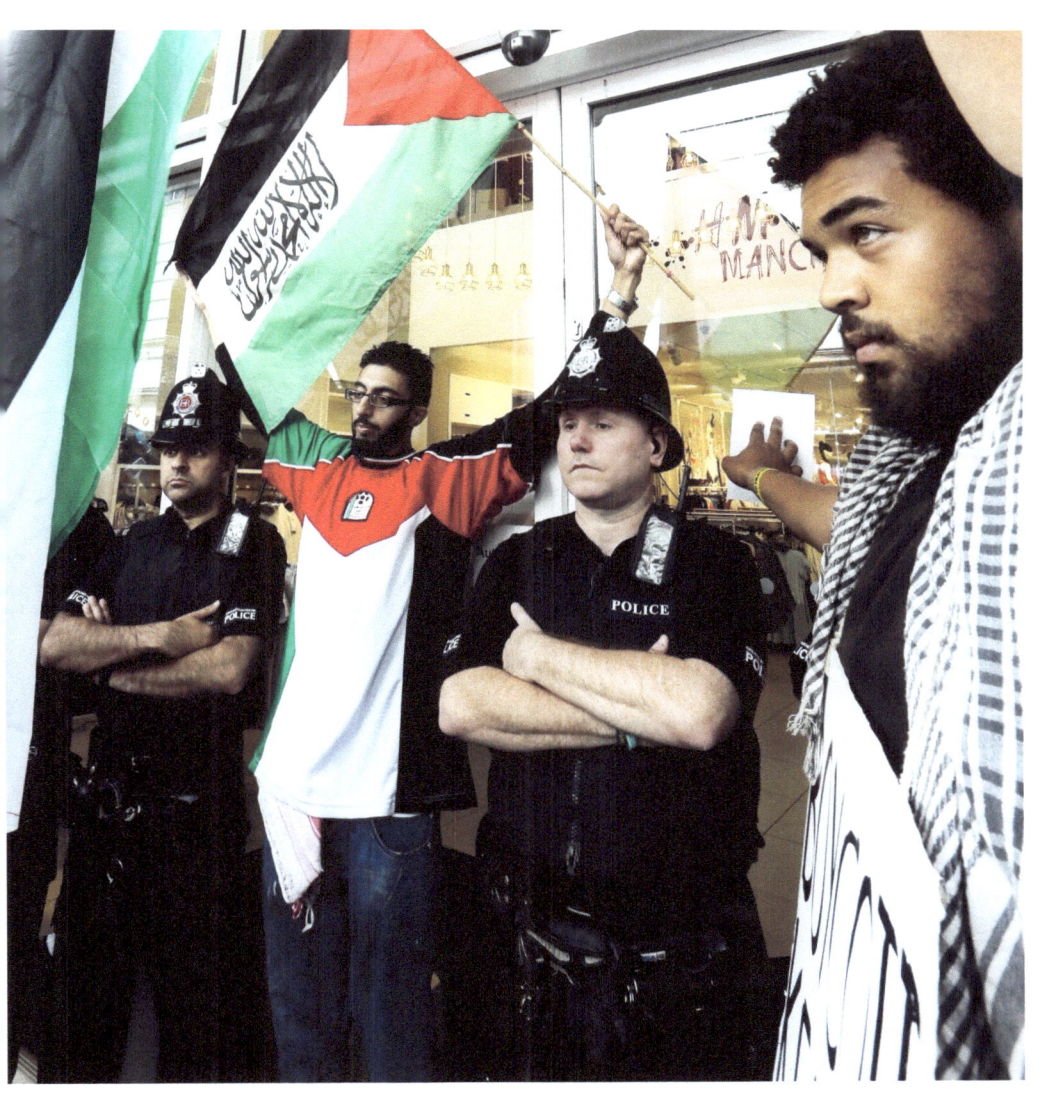

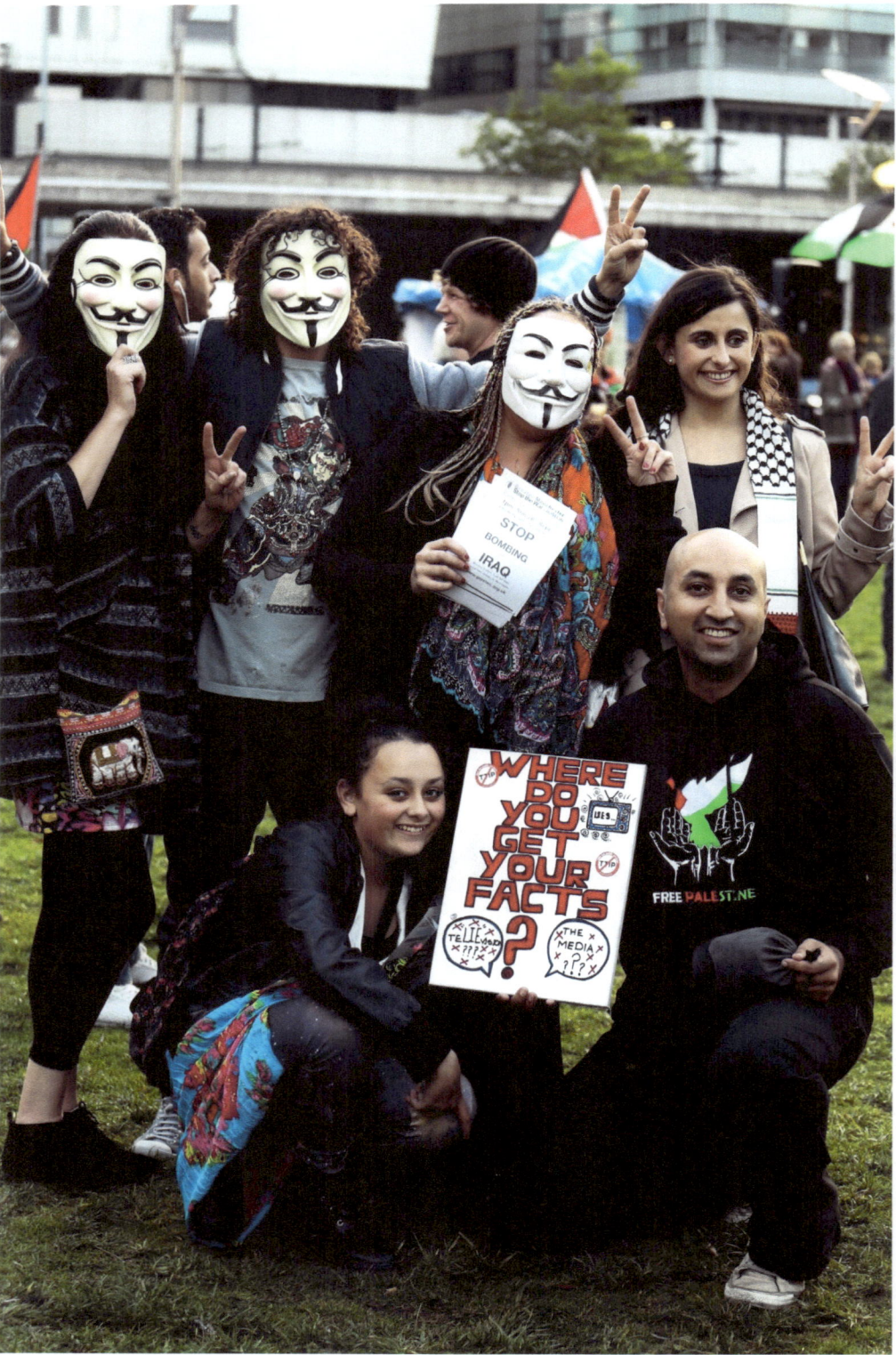

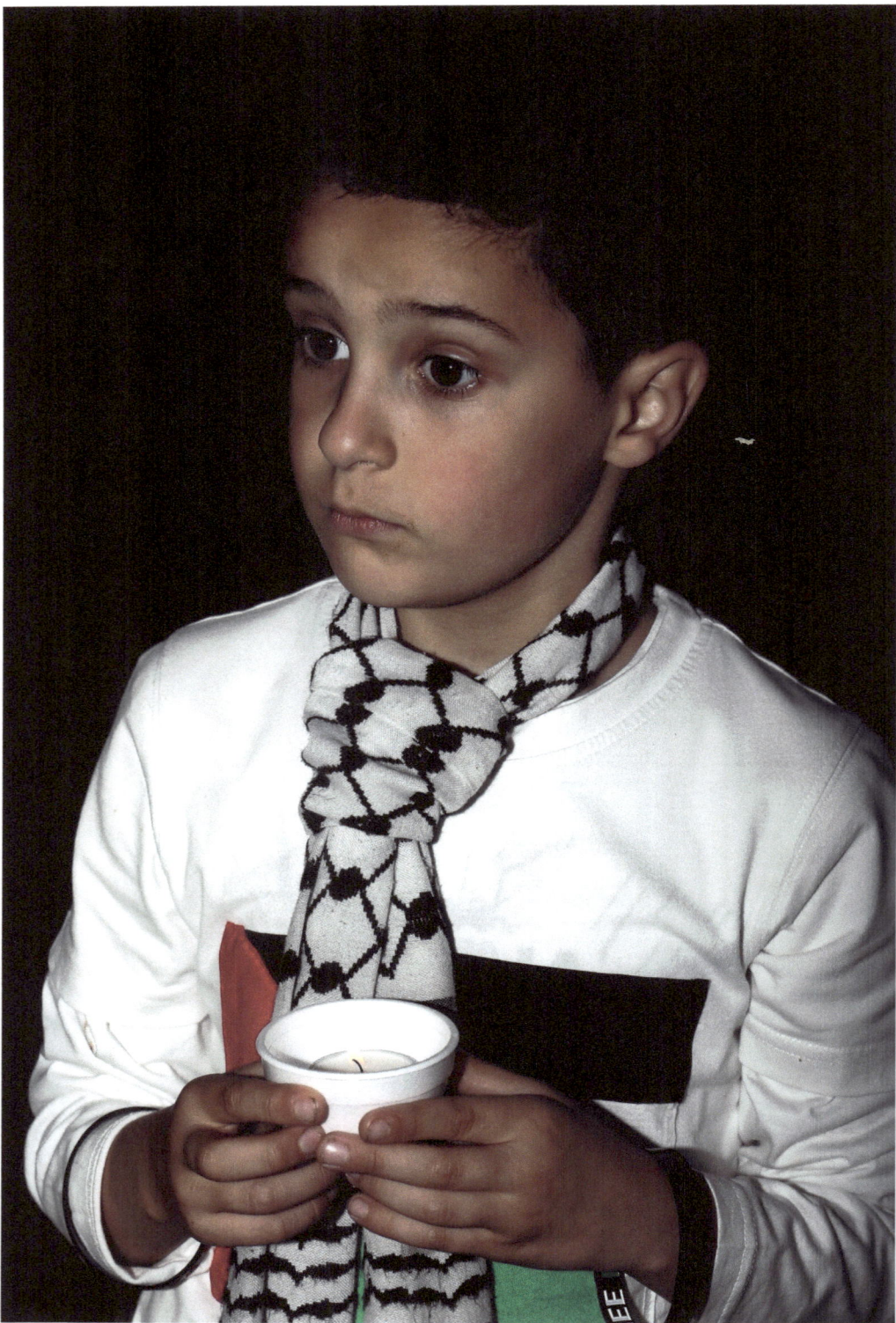

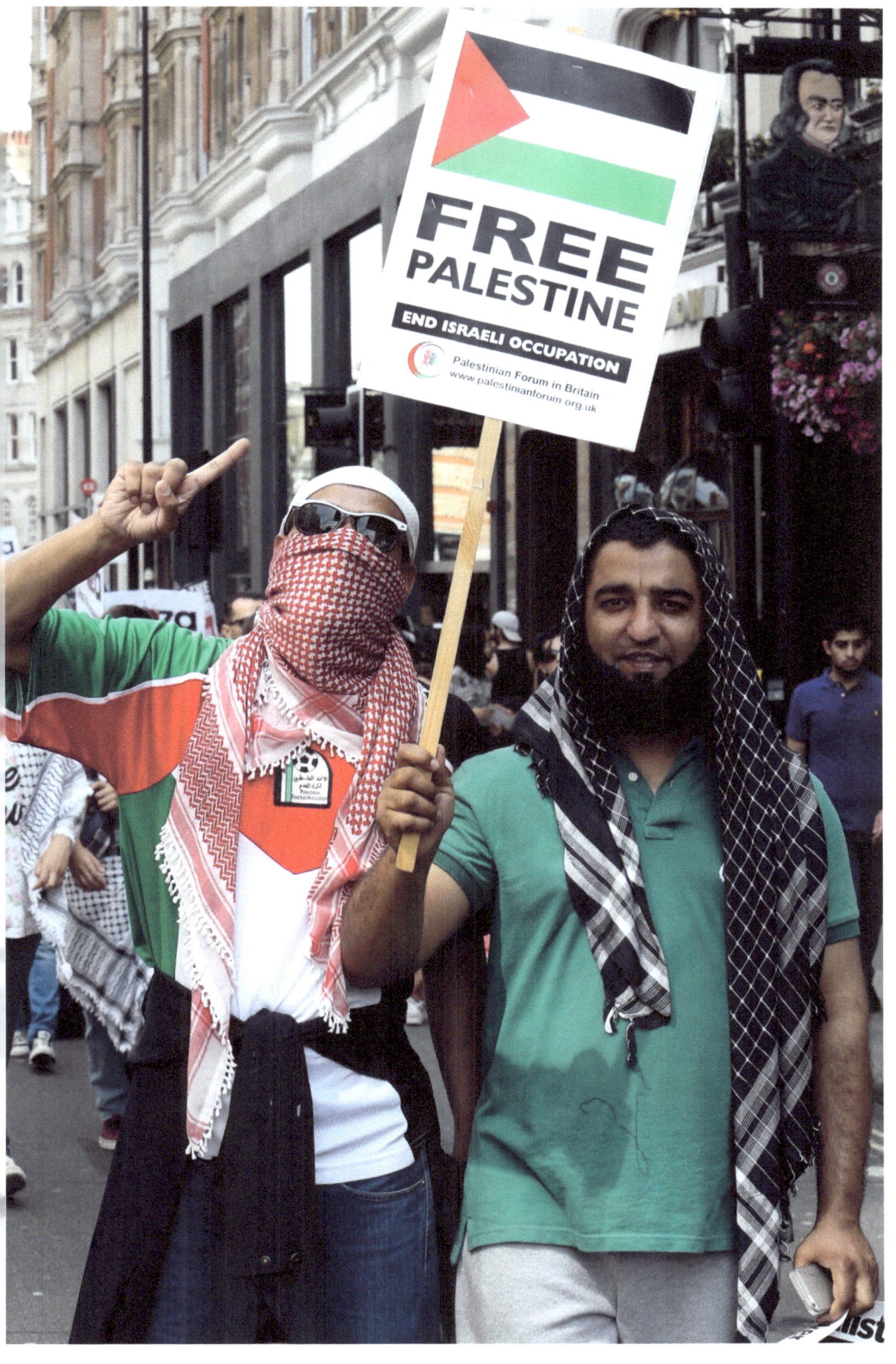

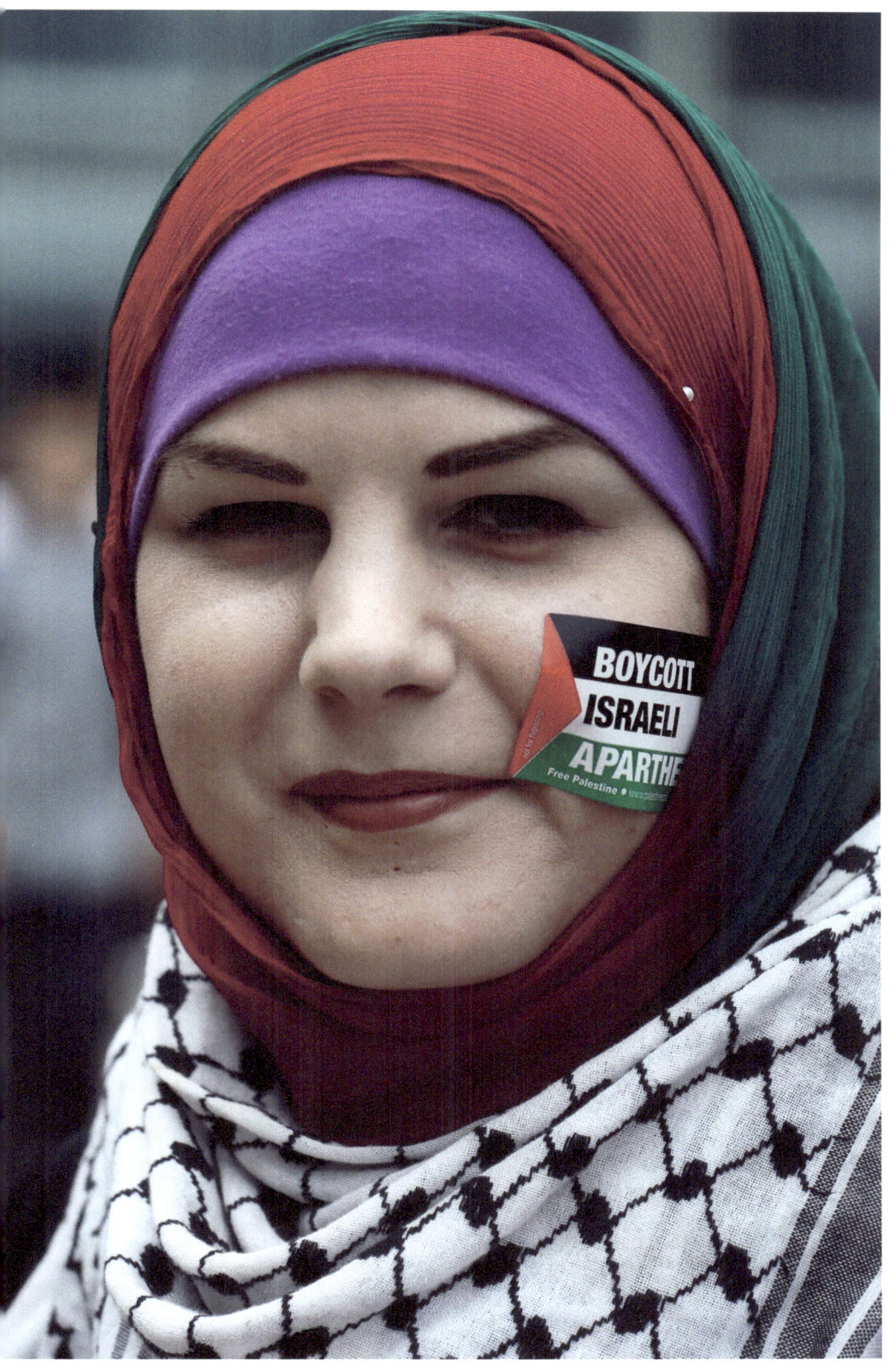

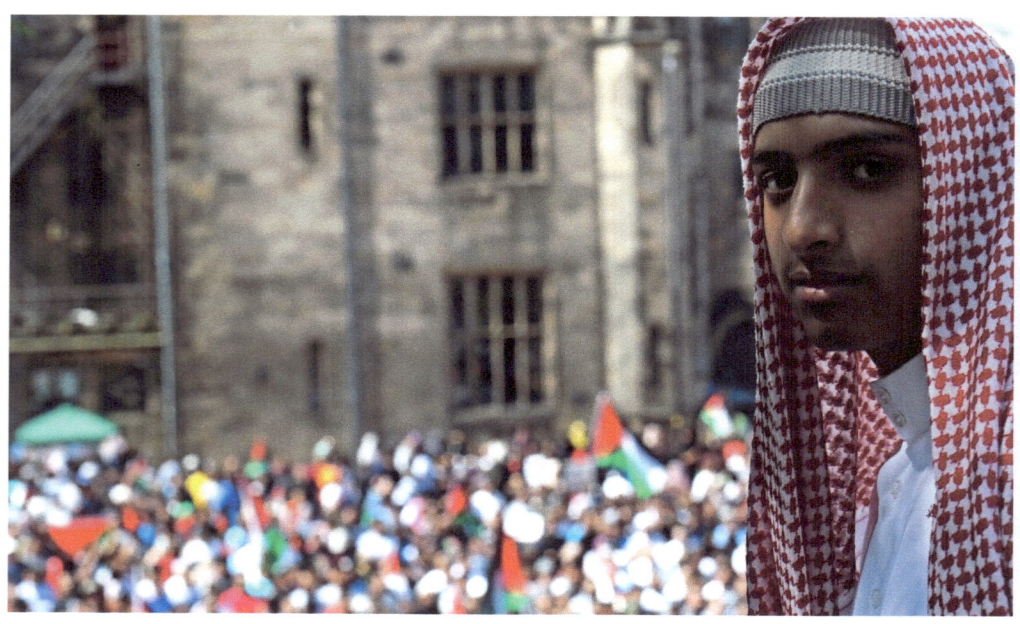

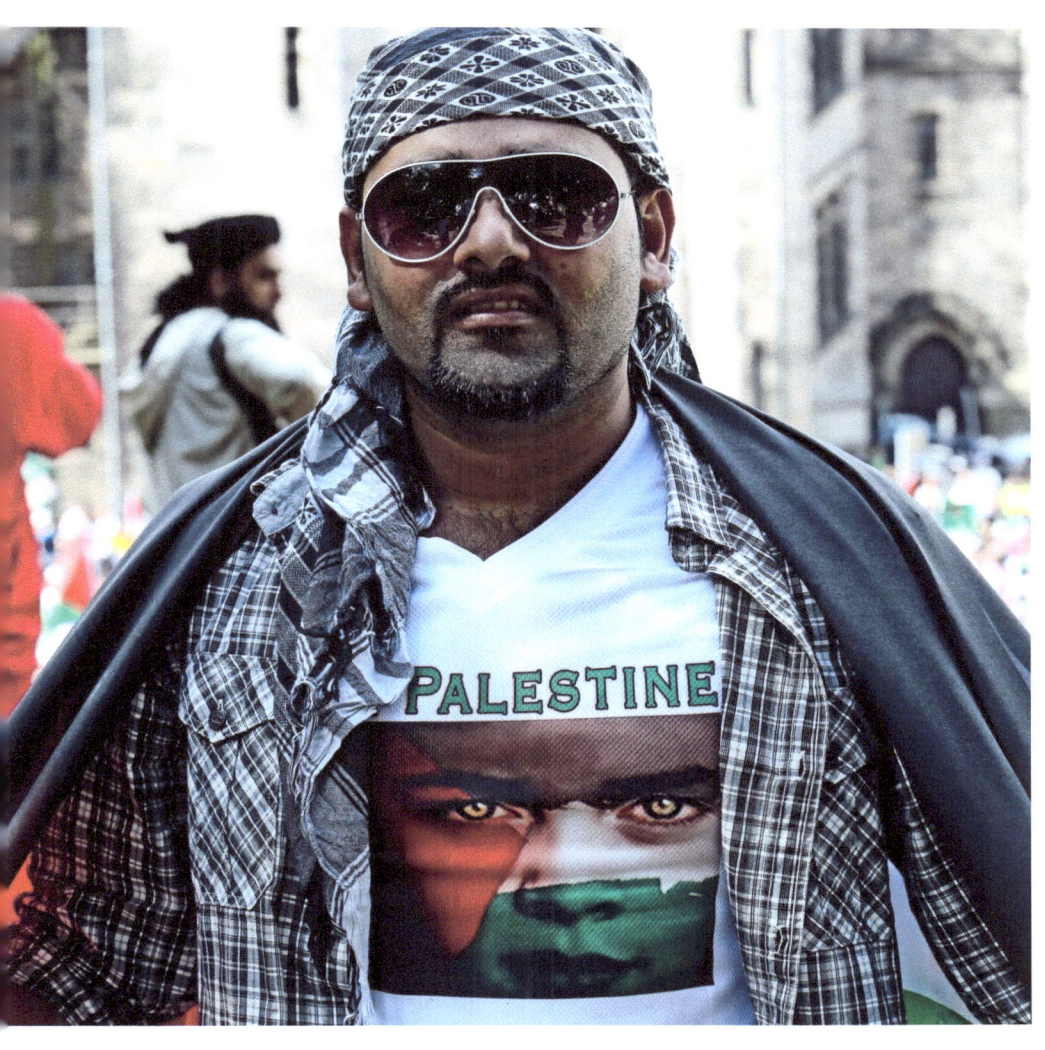

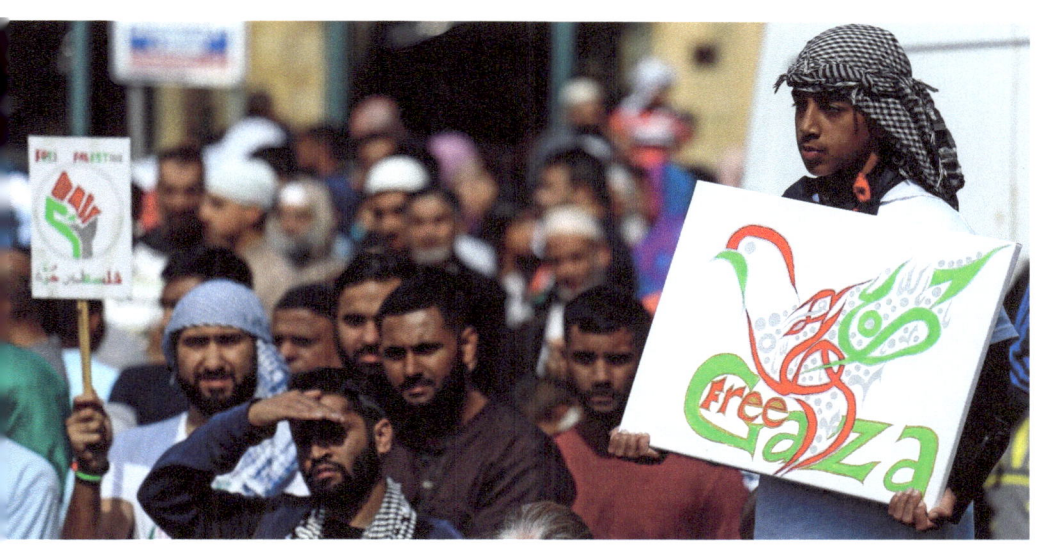

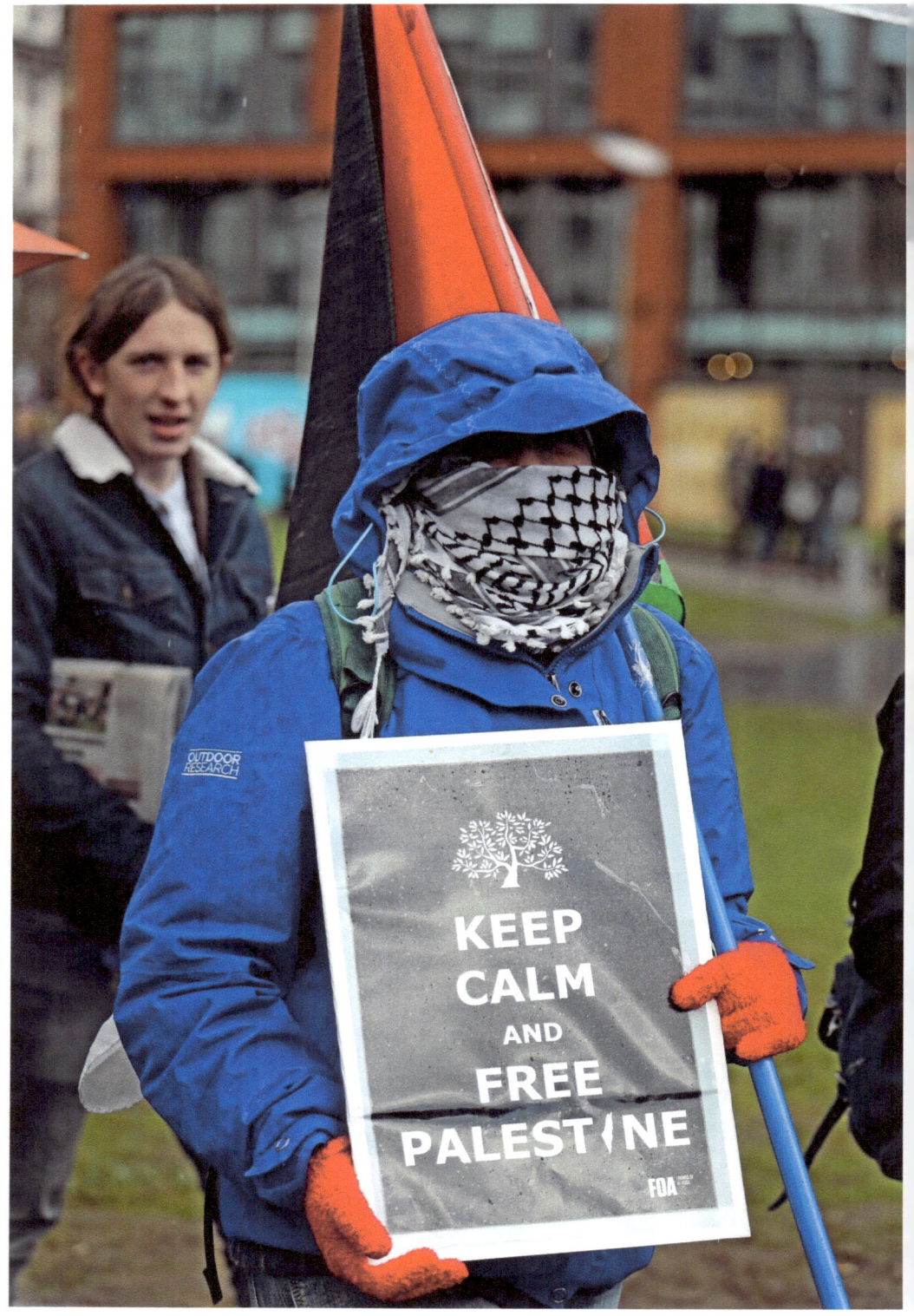

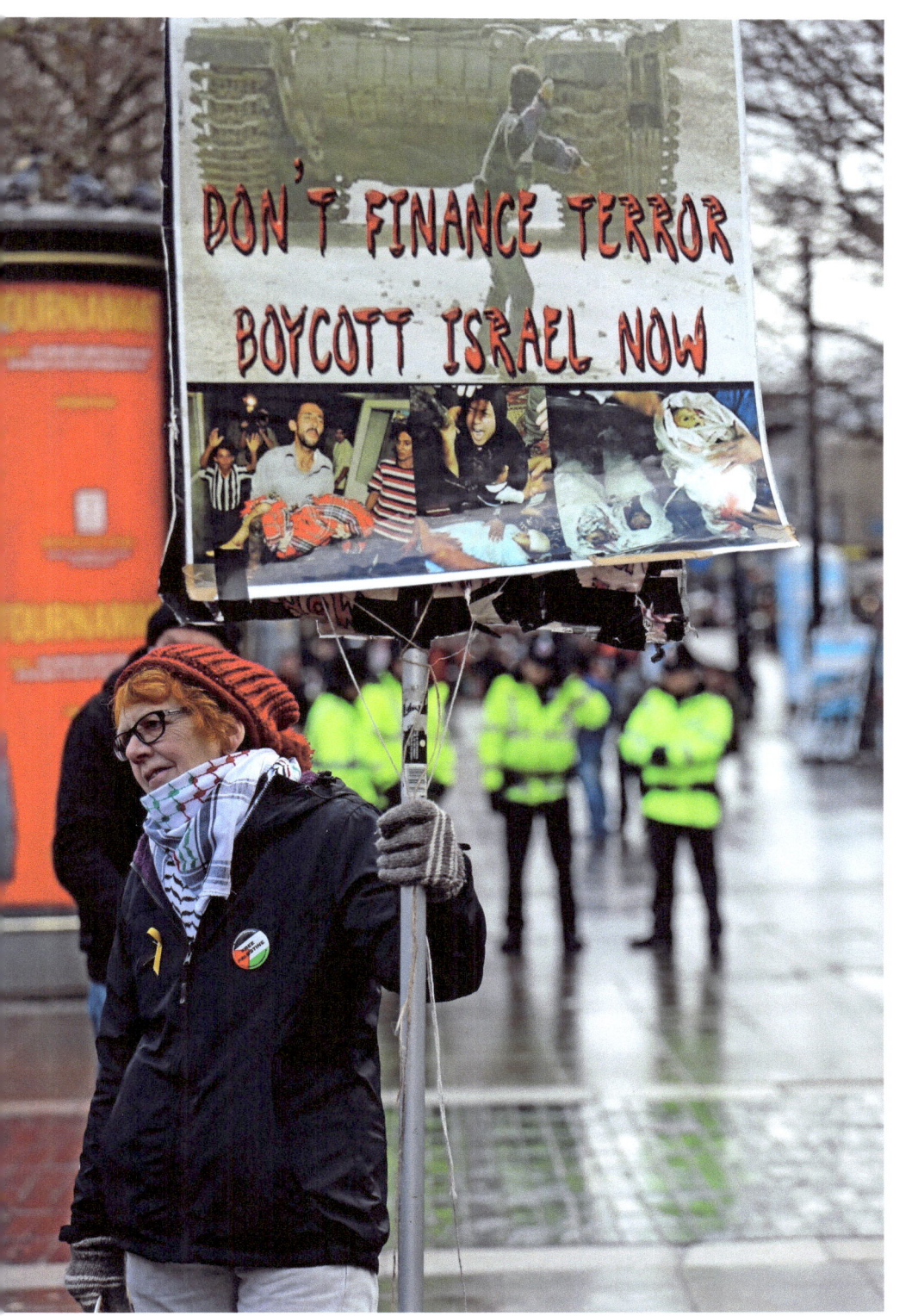

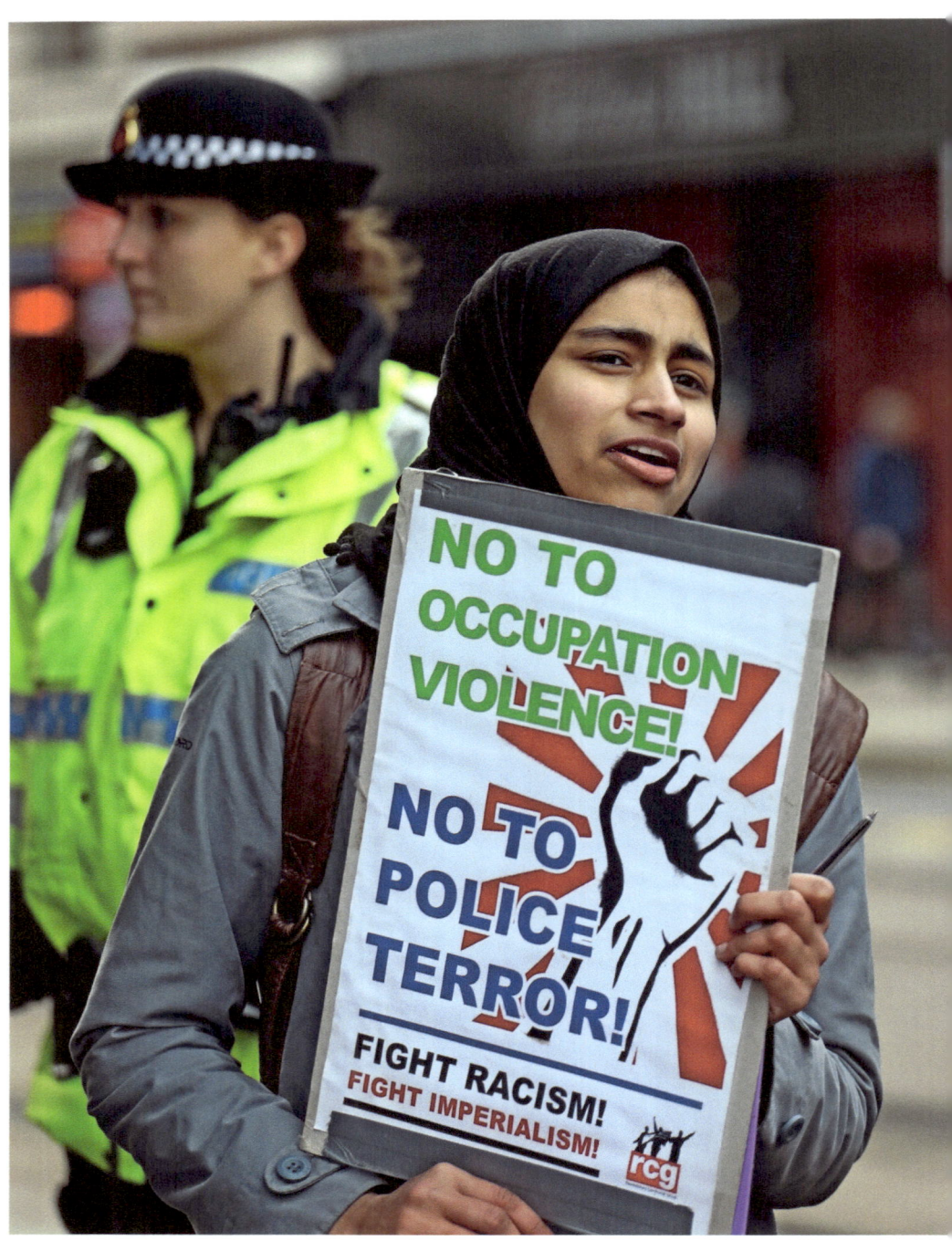

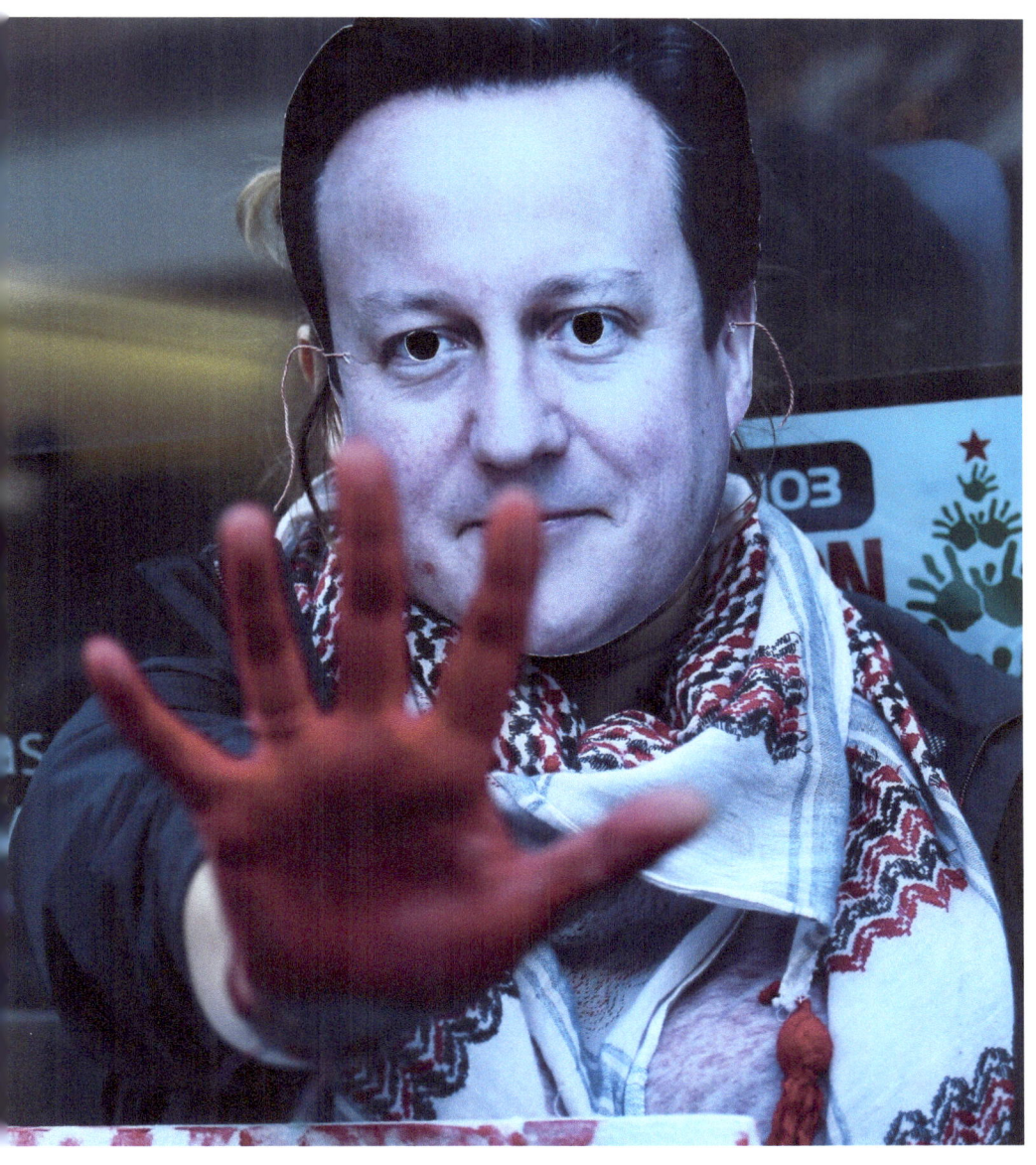

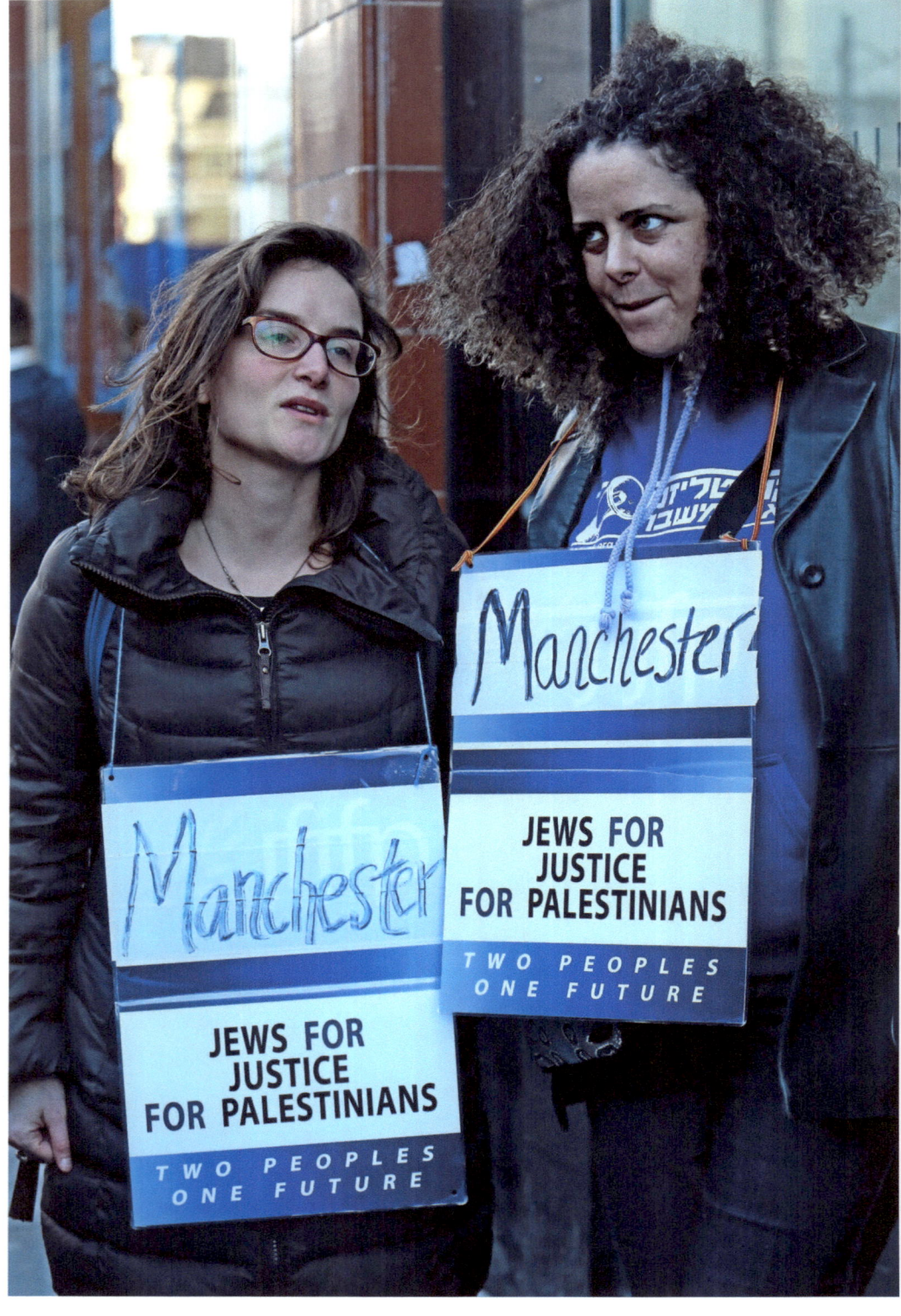

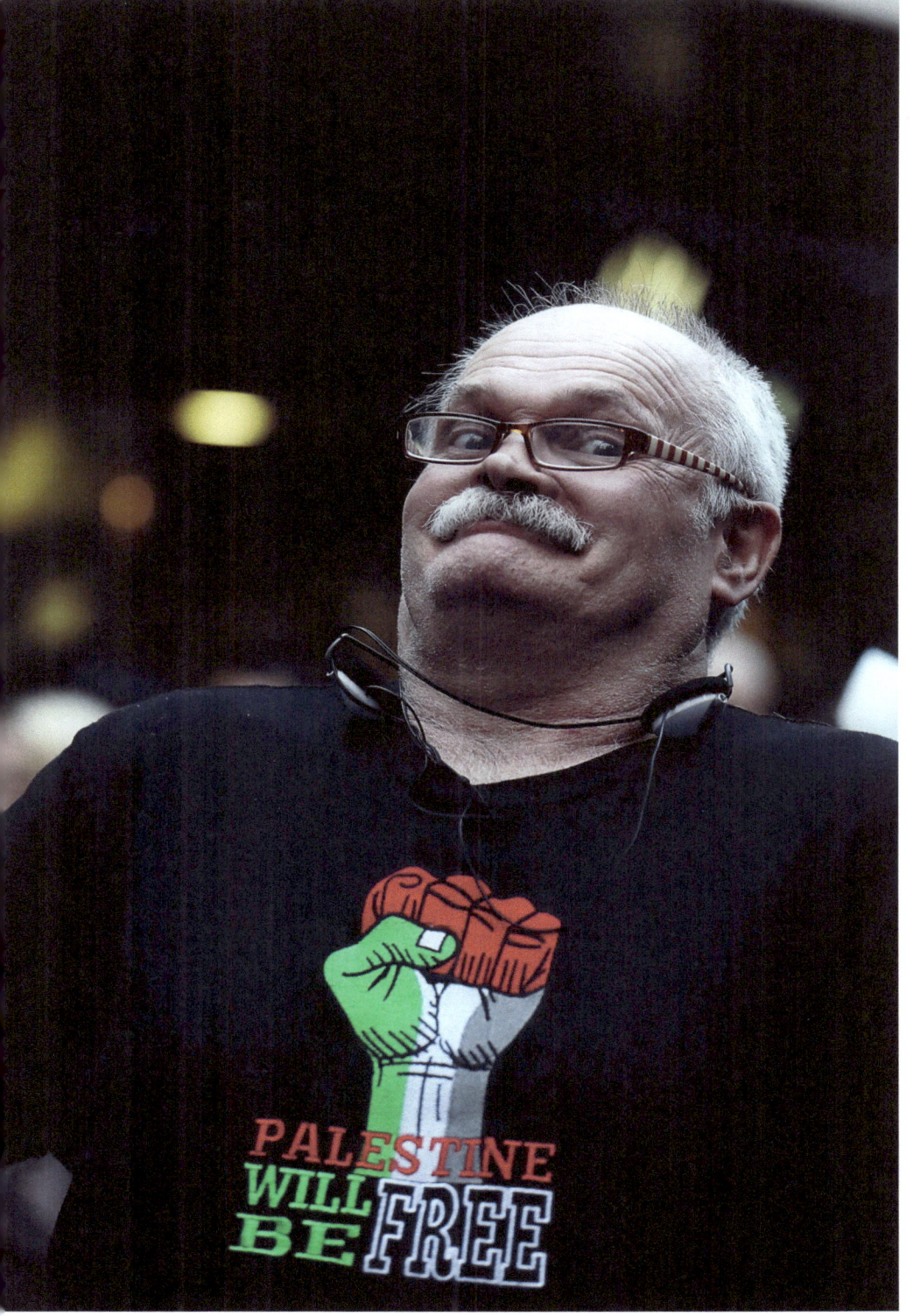

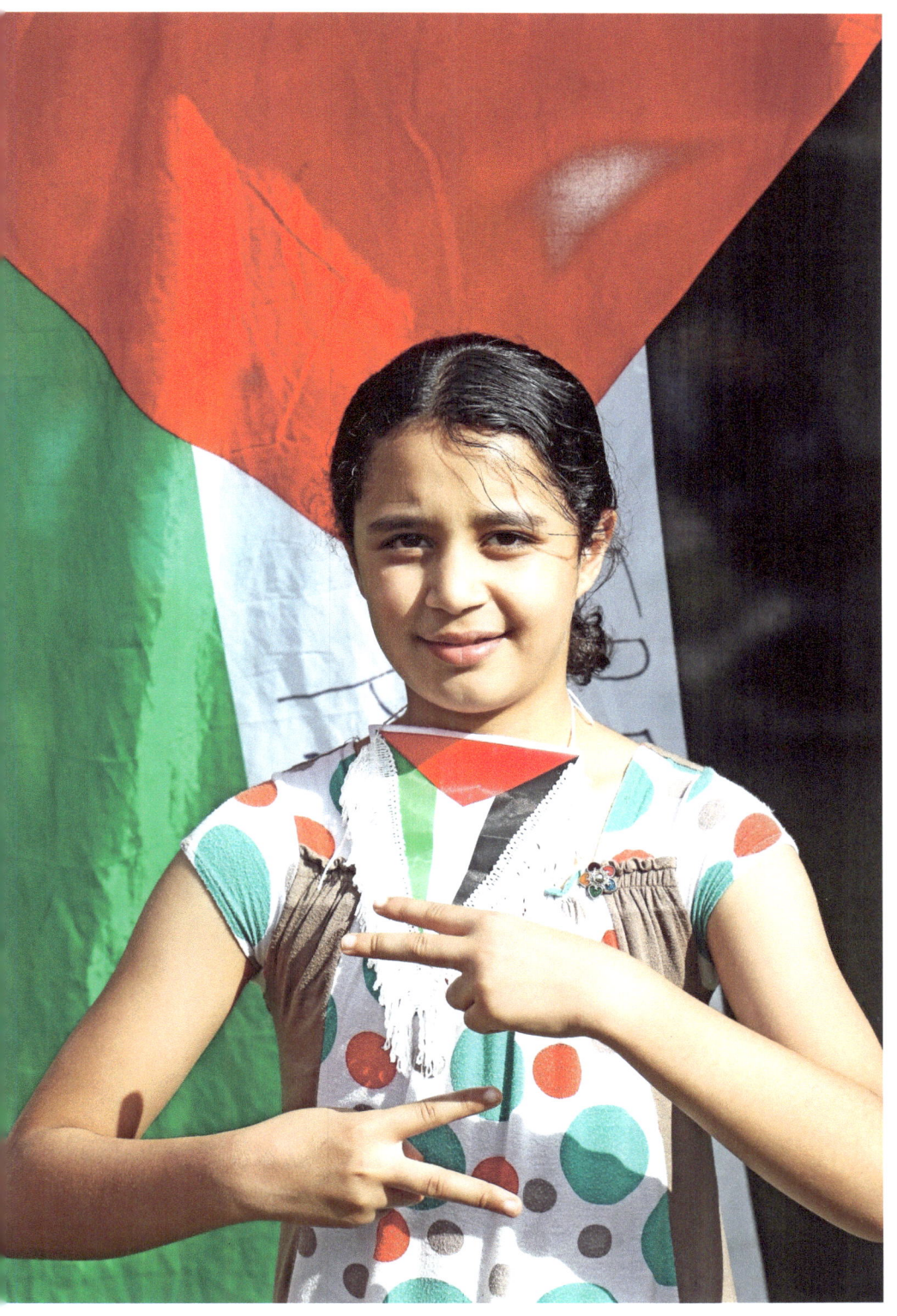

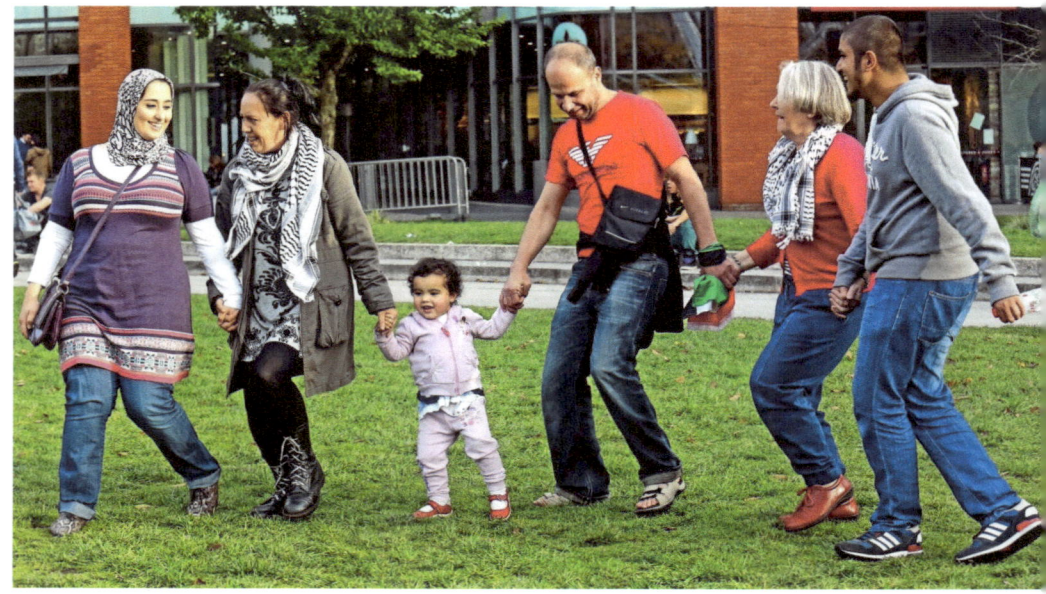

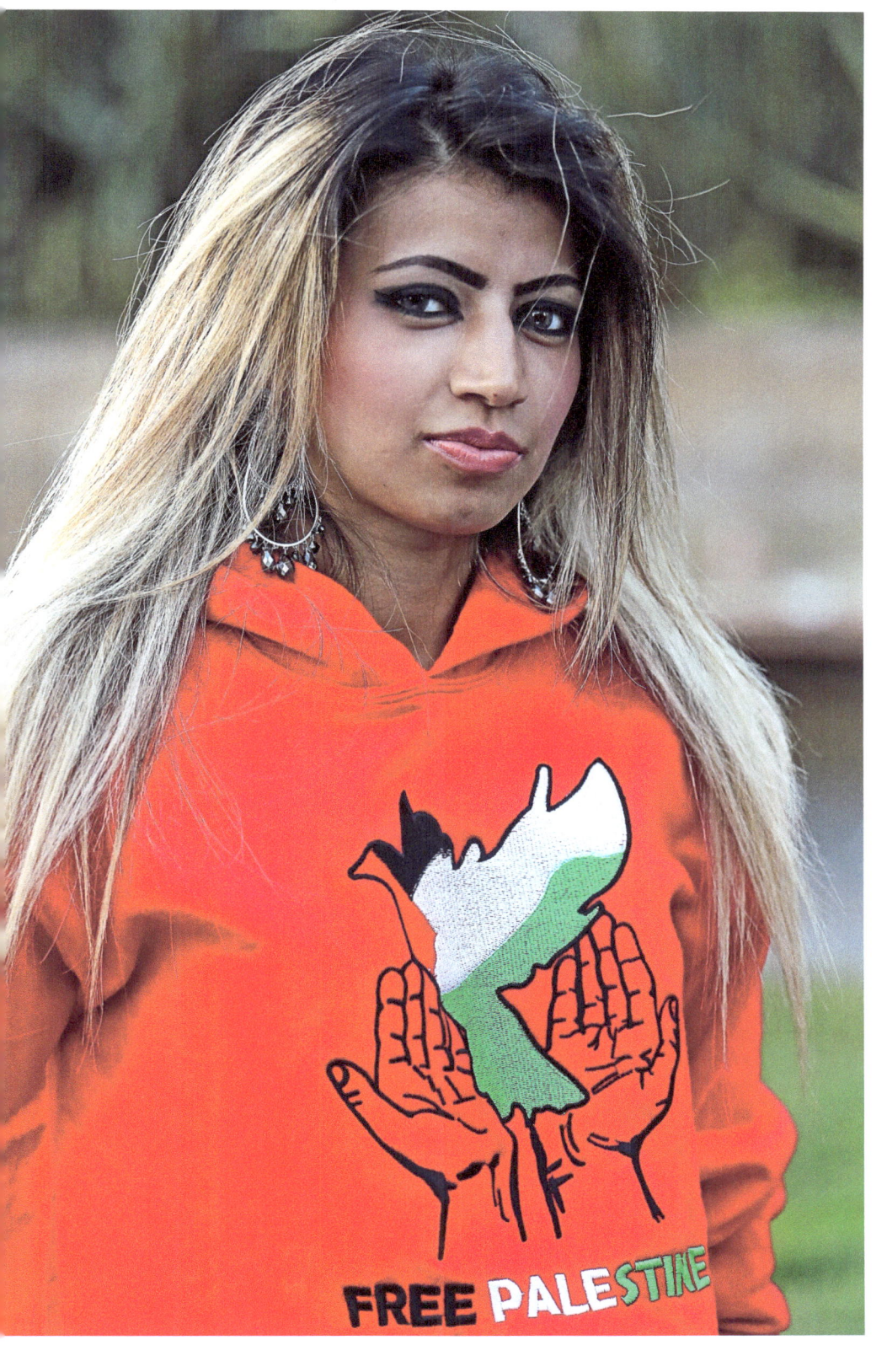

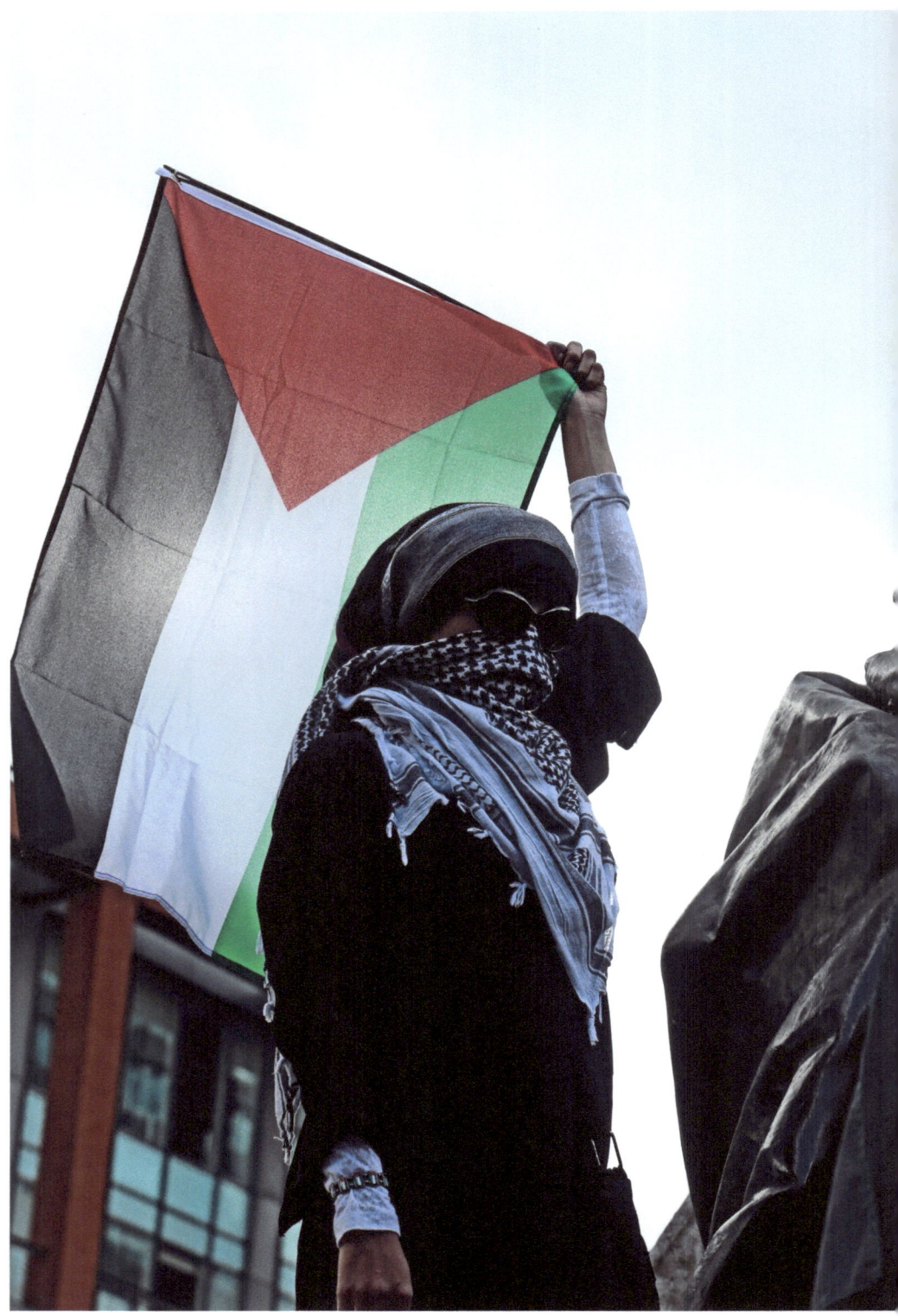

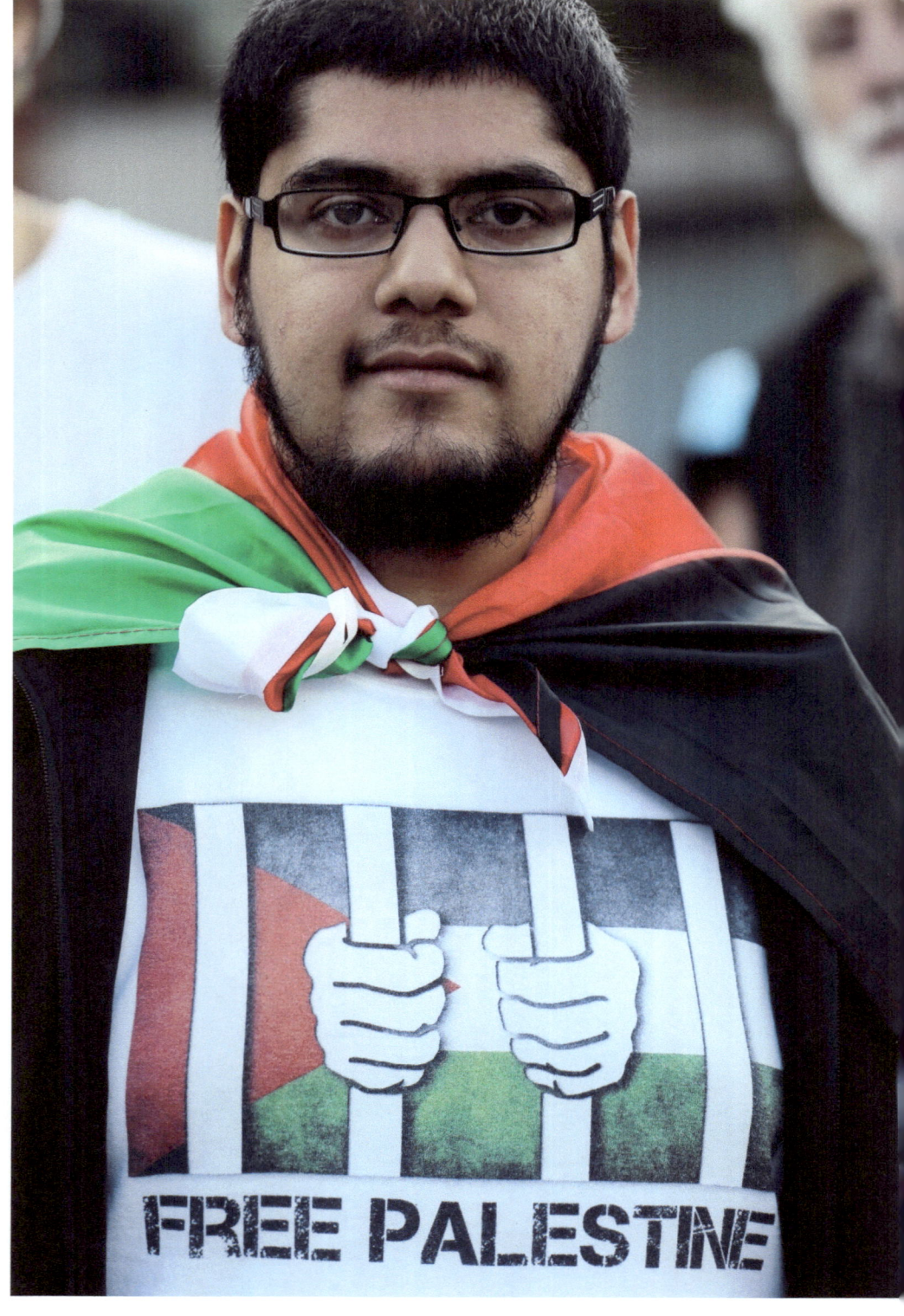

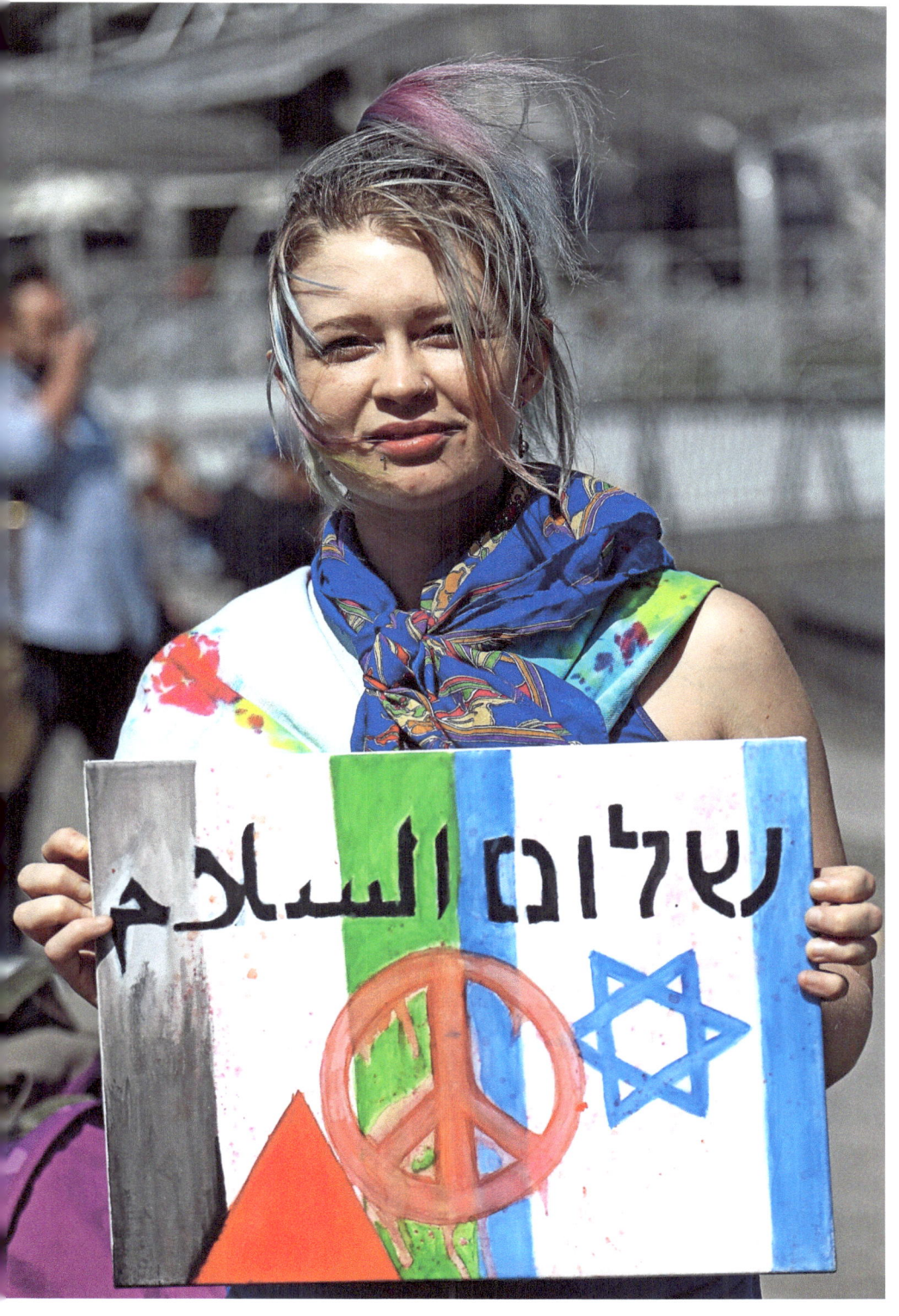

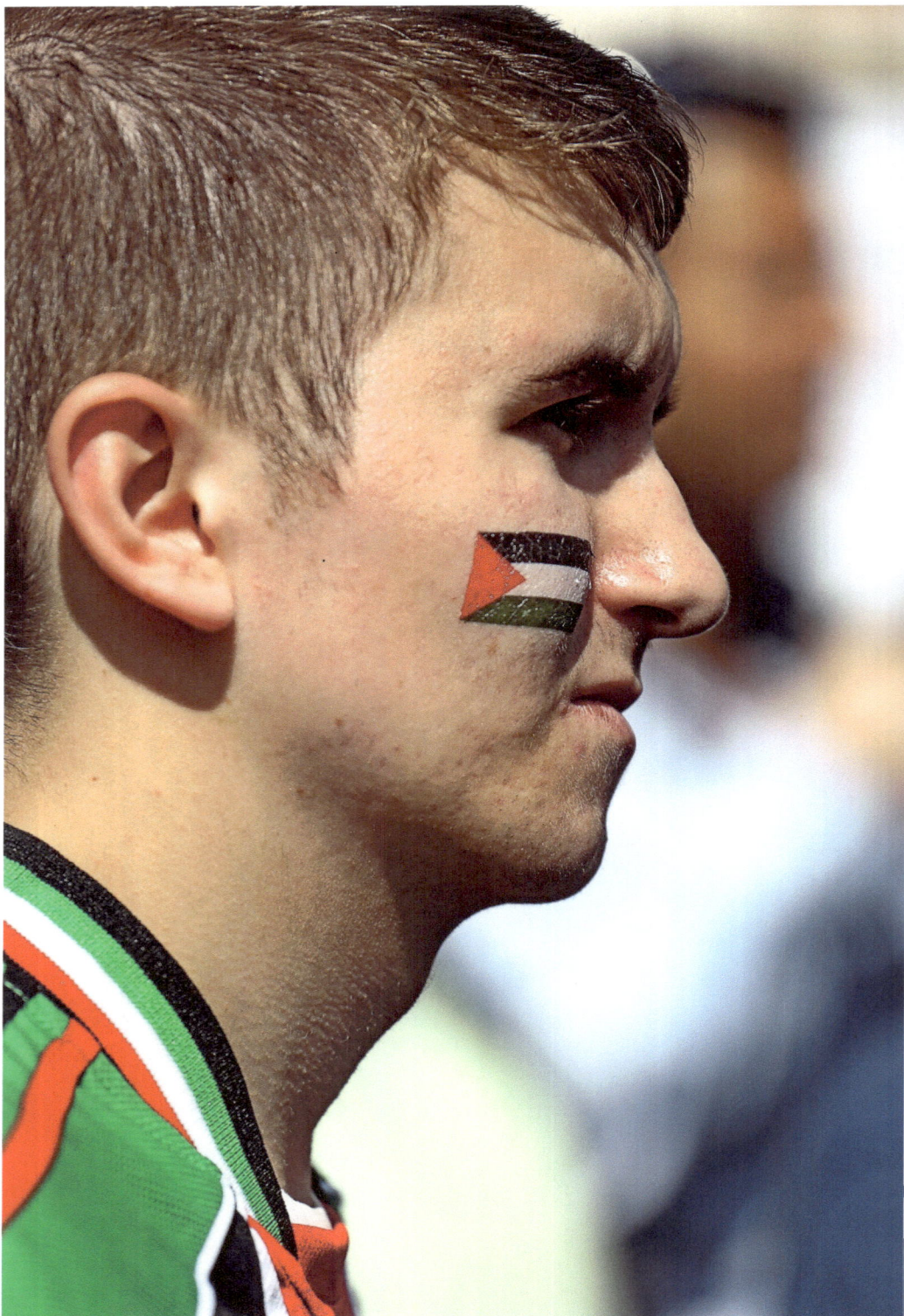

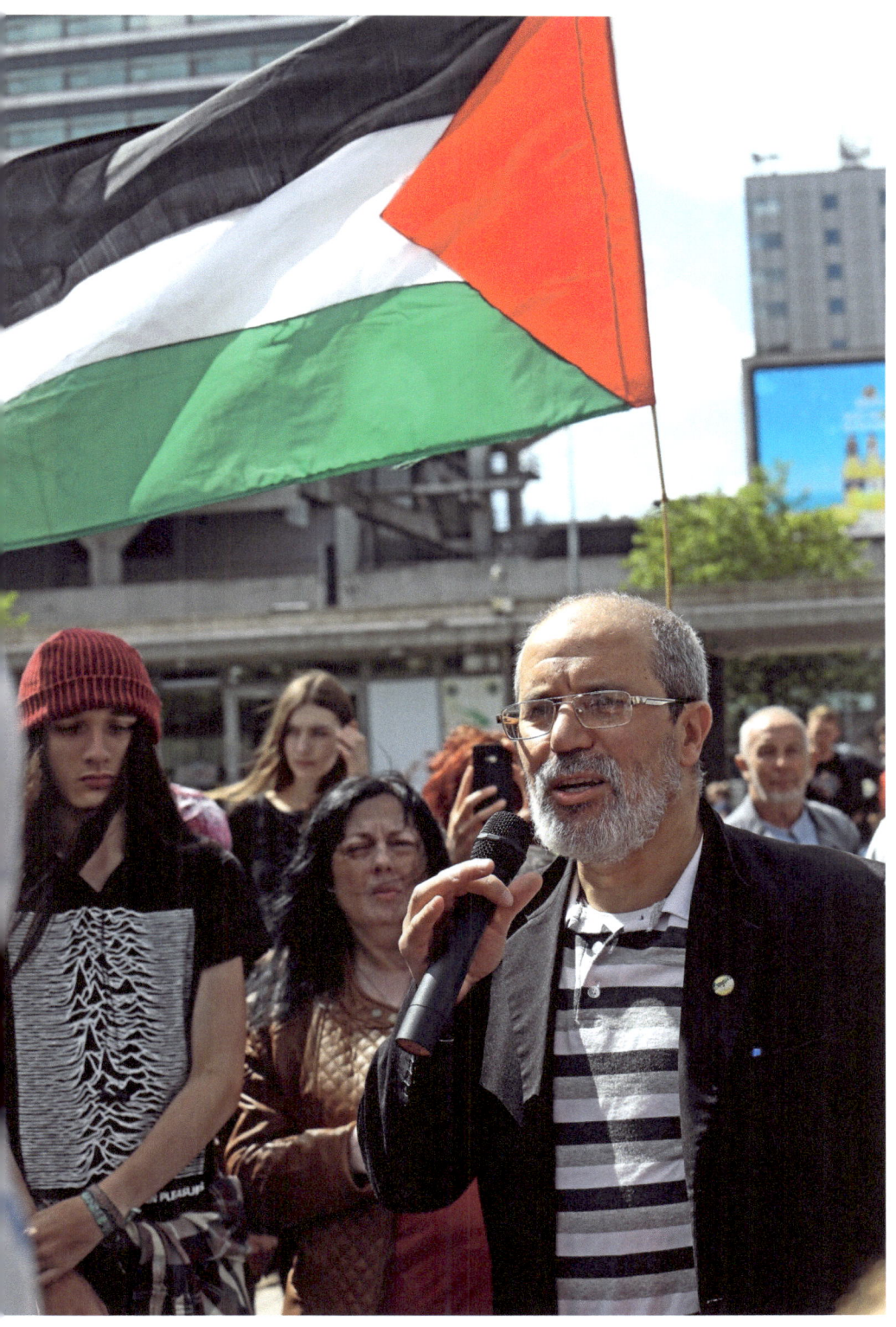

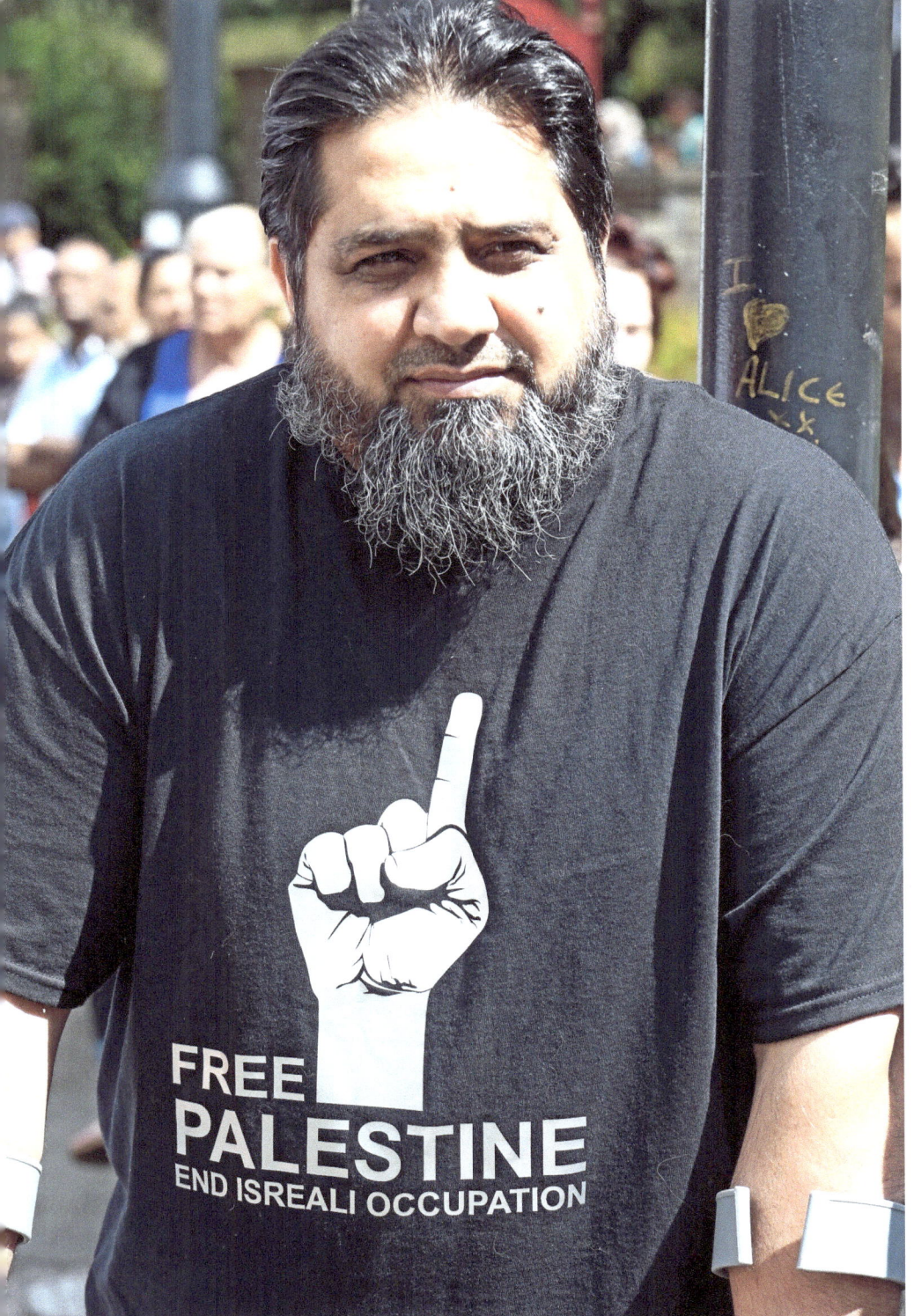

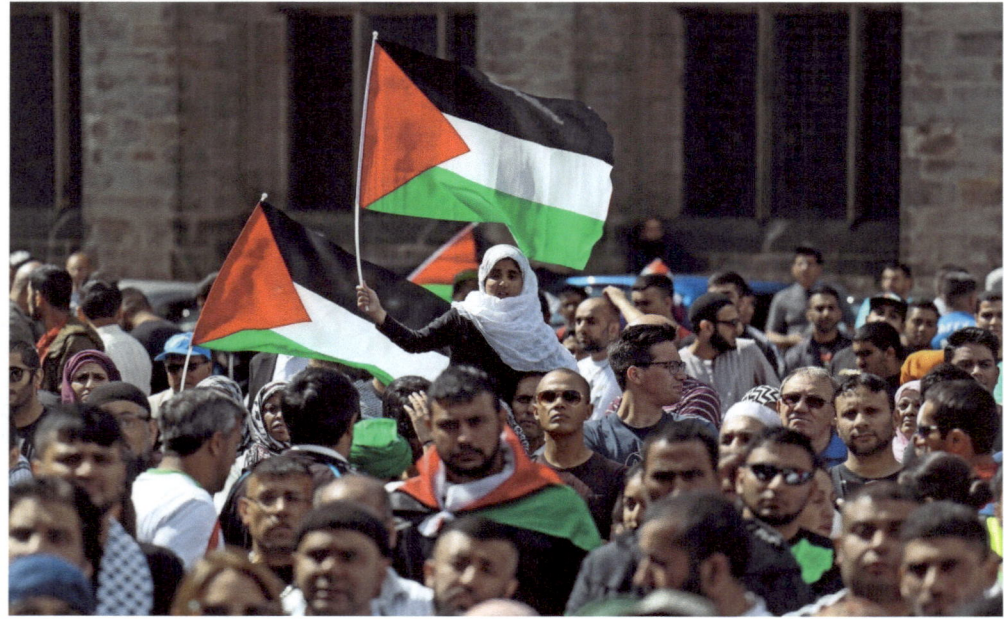

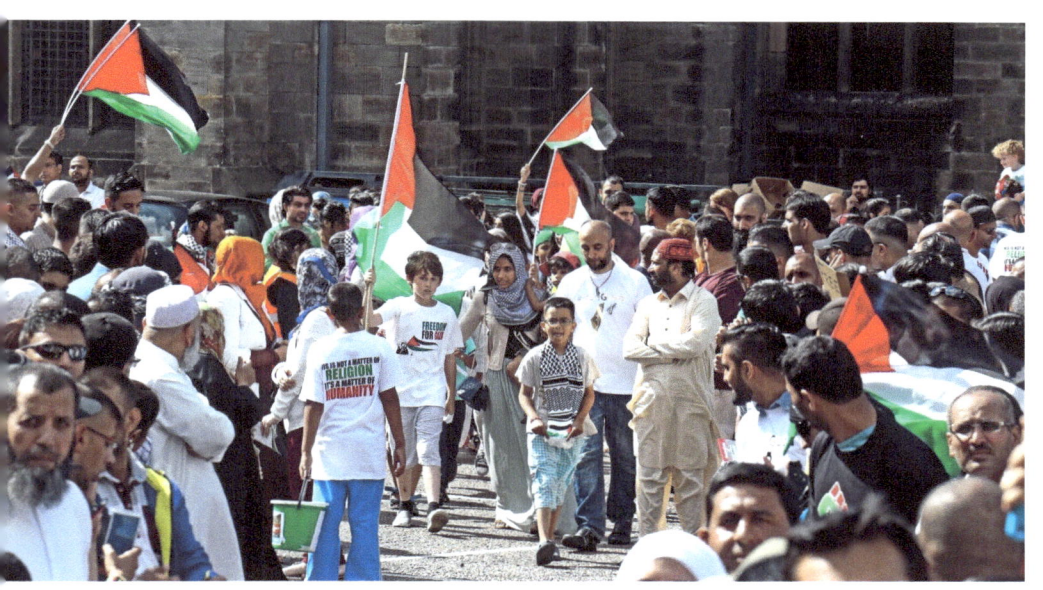

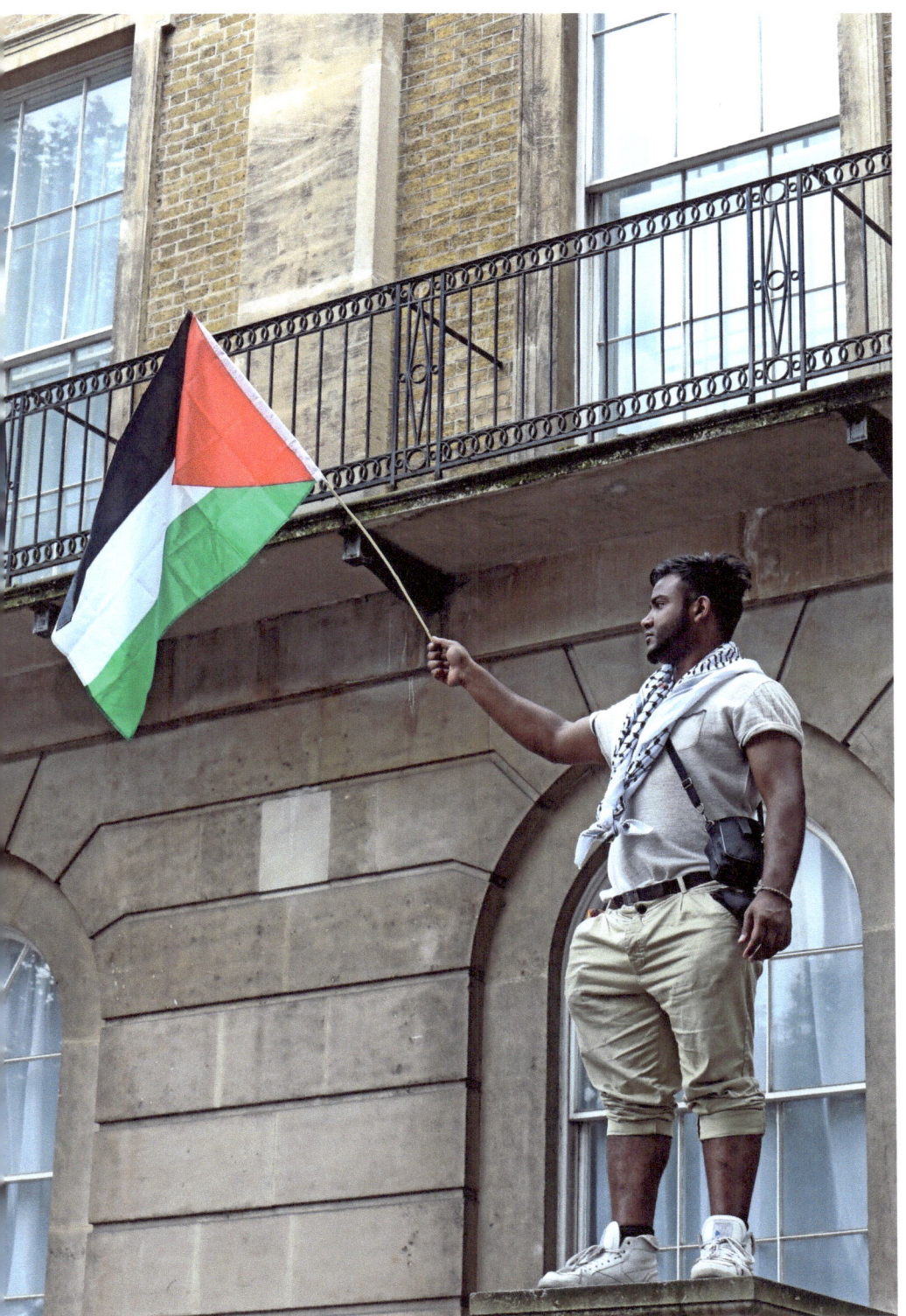

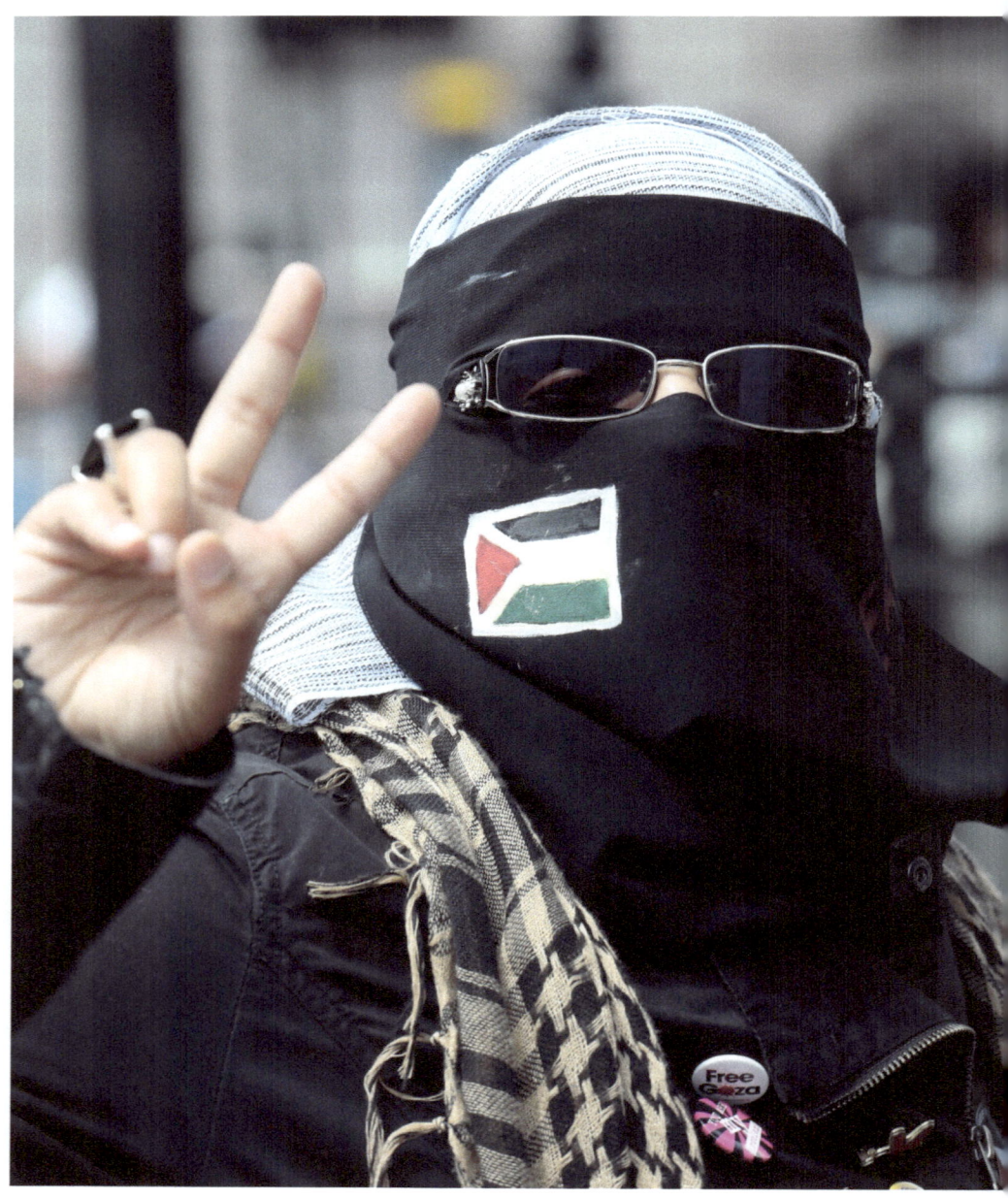

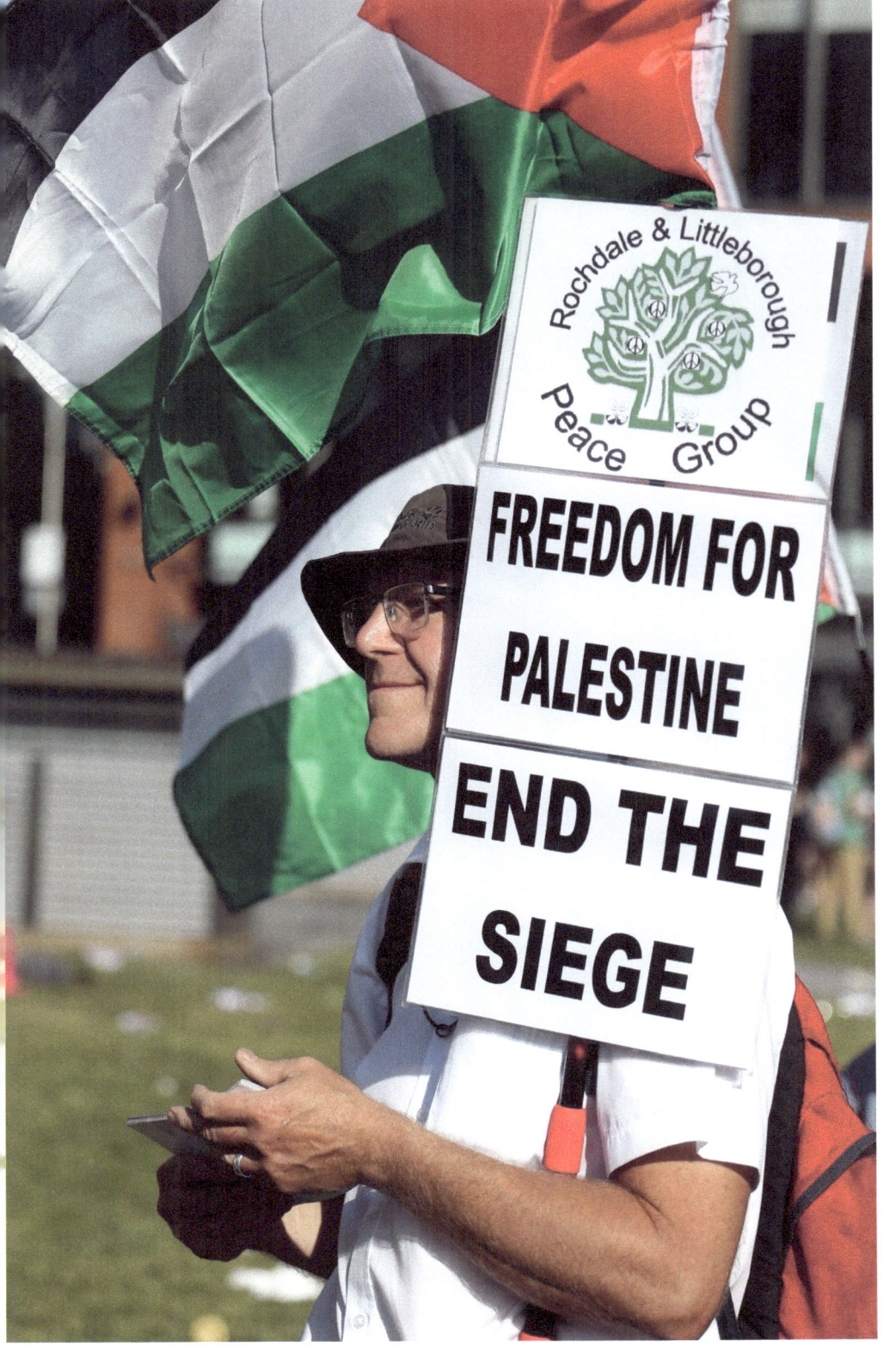

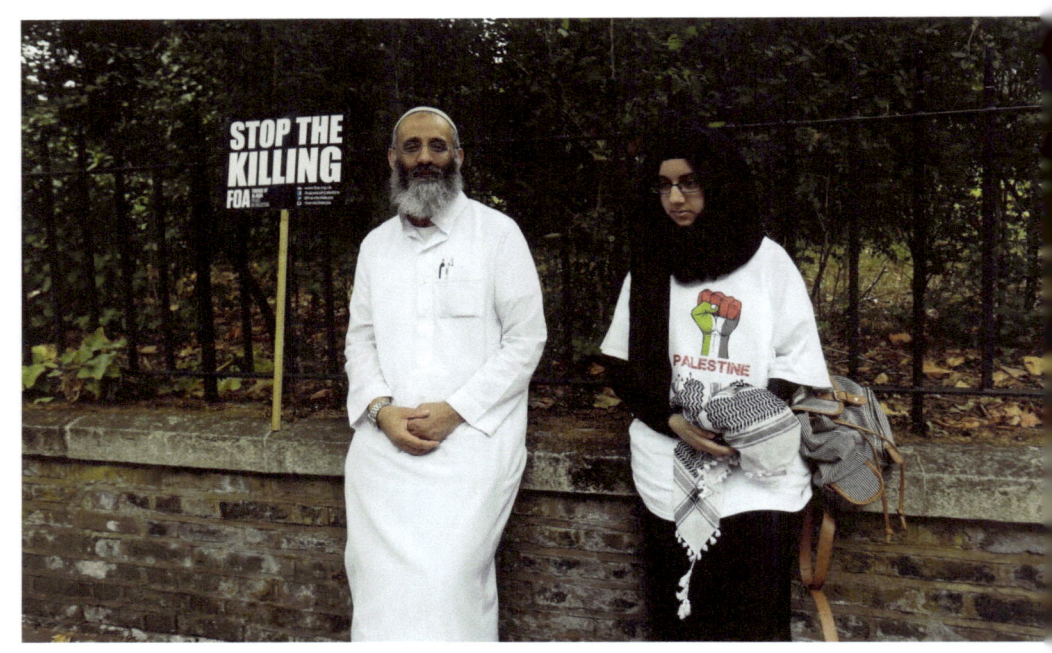

www.ingramcontent.com/pod-product-compliance
Lightning Source LLC
Chambersburg PA
CBHW041110180526
45172CB00001B/188